A SHORT BIOGRAPHY OF CLAUDE MONET

A SHORT BIOGRAPHY OF
Claude Monet

Susan DeLand

BENNA BOOKS
A Boutique Press for Artists & Writers

Carlisle, Massachusetts

A Short Biography of Claude Monet

Series Editor: Susan DeLand

For Joshua

978-1-944038-10-6

Front cover: Claude Monet (French, 1840-1926),
Self-Portrait with Beret, Private Collection.
Back Cover: Claude Monet,
The Japanese Footbridge and the Water Lily Pool, Giverny,1899,
Oil on canvas, Philadelphia Museum of Art,
The Mr. and Mrs. Carroll S. Tyson, Jr., Collection, 1963-116-11.

To request a free copy of our current catalog
featuring our best-selling books, write to:
Applewood Books
P.O. Box 27
Carlisle, MA 01741
Or visit us on the web at: www.awb.com

10 9 8 7 6 5 4 3 2 1
MANUFACTURED IN THE UNITED STATES OF AMERICA

OSCAR-CLAUDE MONET, the painter often considered the father of impressionism, was born on November 14, 1840, in Paris, France. Claude's father, Claude Adolphe Monet, was a grocer, and his mother, Louise Justine Aubrée, was a trained singer who loved poetry. Claude and his older brother, Leon, shared a comfortable early childhood on the rue Laffitte in the 9th Arrondissement of Paris. He was baptized in the local parish church, Notre-Dame-de-Lorrette, as Oscar-Claude. He was called Oscar, and as a child his signature was O. Monet.

When Oscar was five years old, the family moved to Le Havre, on the Normandy coast of France. His father took over the management of his family's thriving ship-chandling and grocery business. This move to the wild and rocky coast would later play an important role in shaping Monet's art. Young Oscar disliked being indoors in school and often escaped to roam the cliffs and beaches. Le Havre was a bustling international port. All manner of ships, boats, and people from different cultures and countries continuously passed through the harbor. His mind was not on his lessons, and he filled his notebooks with drawings of nature and people and caricatures of his teachers.

In 1851, Oscar entered the Le Havre secondary school of arts. He had his first formal drawing class from his instructor, Jacques-François Ochard, who was a former student of the famous neoclassical painter Jacques-Louis David.

Oscar exhibited influence from the best

of both his parents—artistic talent and business acumen. His charcoal caricatures were well known in the town, and at fifteen he sold his first drawing. Soon he was drawing caricatures and selling them for ten to twenty francs apiece. Before long, he had earned 2,000 francs from his art enterprise.

Monet was a young man who grasped early in life that what came most naturally to him was art. His many hours of sketching brought him closer to the expression of form with every line drawn. He met another artist, Eugène Boudin. Eugène was the son of a ship's captain and a self-taught painter. He caught the sea, the beaches, and ships in small, finely executed landscapes while positioned outdoors near the harbor. Boudin owned a frame shop in Le Havre that was visited by painters, including Jean-François Millet, who encouraged Boudin to take painting more seriously. Eugène recognized a market in seascapes for the moneyed tourists who visited Le Havre. Boudin became a mentor to the

His charcoal caricatures were well-known in the town, and at fifteen he sold his first drawing.

younger Monet and changed the path of Monet's art. He taught Monet to use oil paints and *en plein air* techniques, not well known in the mid-nineteenth century. Although landscapes had been painted with oils since the sixteenth century, most were done in the studio. These landscapes were recollections, not direct observations of nature and the transient light and shadow. Boudin is reported to have admonished Monet to stop peddling his caricatures and take in the shifting light that played out dramatic changes on the rocks and fields, animated by the sun and the intensity of the blue of the skies. Boudin and the young man would paint side by side on portable easels using paint in tubes. Now Monet's love of the outdoors and the natural world moved beyond sketches into brilliant colors and technique experimentation that the reflective oils allowed for.

The year 1857 brought life-changing events to Monet. The death of his mother on January 28, 1857, caused Oscar much

suffering. His father's vision for his son was entering the business for a secure future. Madame Monet had recognized her son's talent and supported and encouraged him. Now his mother was no longer there to believe in his art and, at sixteen years old, his home was disrupted. His father decided that Oscar should be sent to live with his widowed, childless aunt, Marie-Jeanne Lecadre, in Paris. Fortunately, his aunt was an amateur painter and encouraged him to continue his training as a painter. He enrolled in the Académie Suisse in Paris, where Monet met the fellow painter Camille Pissarro, who became a life-long friend as they both grew artistically.

Monet was influenced by the paintings of the Barbizon school. This group of artists painted in nature and depicted landscapes as subjects, not backdrops. They worked in the countryside and forests outside of Paris and without need of a studio; they immersed themselves in their surroundings and painted what they saw,

Monet was influenced by the paintings of the Barbizon school.

not from memory. The forest of Fontaine-bleau was 42,000 acres of woods, marshes, and meadows. Barbizon was one of several small hamlets on the edge of the forest. In the 1820s, artists began making the short trip to Barbizon during the warm summer months. A new inn, Auberge Ganne, offered room and board and became a gathering place at the end of a day in the forest, the artists sharing lively conversations about techniques, materials, and ideas. Rousseau and Millet were so drawn to the rich flora of the preserve that they lived there year-round, Millet and his wife raising nine children in a simple cabin. These painters set the stage for the Impressionists.

Monet met the Dutch painter Johan Barthold Jongkind. Jongkind was an acclaimed marine landscape painter, and his brush seemed driven by the chop and loll of the ocean. Jongkind worked in both Le Havre and Paris. Monet later said that Jongkind was the definitive influence on his own painterly eye.

Monet entered the First Regiment of the African Light Cavalry in June of 1861. He signed on for a seven-year commitment, to be stationed in Algiers, Algeria. He was fascinated by the color and light of Africa. His choice to be stationed there may have been a result of his admiration for Eugène Delacroix, who infused his paintings with the rich and exotic colors of Morocco. After two years, Monet contracted typhoid fever. Tante Marie-Jeanne intervened and succeeded in getting his release from the army. Claude promised to study art. It is possible that Jongkind influenced this decision. Monet was disillusioned with the traditional art being taught and entered the independent atelier of Charles Gleyre and a world filled with young painters pushing the boundaries of accepted norms.

By this juncture, Oscar had begun using Claude as his first name and signing his works "Claude Monet." Through Gleyre, Claude encountered Pierre-Auguste Renoir, Alfred Sisley, and Frédéric

He was fascinated by the color and light of Africa.

Bazille. Édouard Manet became an influence on Monet's figure compositions, though a long irritation based on many people's confusion of their names clouded their relationship. These young men shared a passion for a new approach to art, embracing *plein air* and transforming the natural light and world around them by using rapid brushstrokes that jarred the colors, a style that later came to be called *impressionism.*

Claude grew into a man, and his painting became more confident and explorative. He became fascinated with *japonisme.* Later in his life, he collected Japanese art and objects, including 231 woodblock prints, many of them by Katsushika Hokusai. Hokusai created many landscapes as well as his now-iconic austere waves framing Mount Fuji, frothing, woodblock prints in rich indigo and Prussian blue inks. Hokusai intensely explored his subject, Mount Fuji, making thirty-six works from different angles, seasons, and composition; the result is *Thirty-Six Views*

of Mount Fuji (*Fugaku Sanjūrokkei*). Arguably influenced by Hokusai, Monet explored several subjects with the same almost-scientific intent. He made a series of thirty haystacks documenting the effects of light, season, and angle on his compositions. He painted thirty versions of the Rouen Cathedral and then narrowed the collection to twenty paintings for exhibition.

"Everything changes, even stone."

His series paintings focused on the same structures or objects, but showed them in morning, midday, and evening light; in sunshine and fog; in different seasons. This repetition exemplified Monet's lifelong fascination with the effects of light. Other series included The Waterloo Bridge, London, and images of poplar trees. Toward the end of his life, Monet painted nothing but the water lily pond and the garden he tended at his home in Giverny. Claude Monet used the

Claude Monet used the word *enveloppe* to describe the air that lay between him and his subject.

word *enveloppe* to describe the air that lay between him and his subject. Looking at these exquisite paintings as a group, the viewer will see that Monet painted the *enveloppe* as it affected the color and texture of his subject.

> *"To me the motif itself is an insignificant factor; what I want to reproduce is what exists between the motif and me."*

As a young man, Monet and his colleagues used the immediacy of the natural setting and a flicking brush to portray the light and air on their subjects. As Monet grew older, he began his painting *en plein air* and then spent hours in his studio, sometimes painting two canvases simultaneously, meticulously coaxing out the impressions made on him when he deeply observed the water lilies or haystacks in the field.

Reflecting Paris' growing obsession with *chinoiserie* and his own interest in *japonisme,* Monet painted his lover, Camille

Doncieux, wearing a vibrant kimono and surrounded by fans. Monet later considered this staged work "trash."

Monet later considered this staged work "trash."

Monet suffered from depression and self-doubt throughout his life. At times he would become frustrated with his work. Over his lifetime, he destroyed hundreds of paintings by burning or slashing them. His drive for the canvas becoming the perfect representation of his vision may have forced these causualties.

In the mid-1860s, Monet and his friends completely embraced *plein air* painting, completing a canvas entirely outdoors. Claude Monet had two marine landscapes selected for the juried Salon of 1865 in Paris. This exposure garnered critical praise but had little impact on Monet's dire financial situation. The following year, Monet was selected again to show in the Salon. The jury selected a landscape and a portrait called *Camille,* or *Woman in Green.* The portrait was of his lover and future wife, Camille Doncieux. Camille, in her teens and seven years younger than Claude

when they met, was his muse and frequent model; her image is part of some of Monet's most inspired works. Camille became Monet's mistress soon after beginning to model for him. Claude was drawn to her intelligence, lustrous dark hair, and intense eyes. Camille and Claude worked together during the years of Monet's deepest suffering. The full-length painting *Woman in Green* was purchased at the Salon by Arsène Houssaye for 800 francs—a fabulous sum for a young and fairly unknown artist. As a result, Monet was commissioned to paint the portrait of Madame Gaudibert of Le Havre.

Riding the wave of success with *Woman in Green,* Monet painted Camille in *Women in the Garden,* portraying the light falling on a small group of women enjoying a sunny, leafy garden. Camille posed for all four of the female figures in the eight foot-high painting. Monet submitted this painting for the Salon of 1867 and the jury rejected it, determining that it was outside of academic stan-

dards. This rejection brought Monet to financial despair. Camille was pregnant, and Claude's father was enraged not only by Monet's choice of becoming an artist instead of a businessman, but by his relationship with Camille. In 1867, Claude and Camille's first son, Jean-Armand Claude, was born. In 1868, financially strapped, with a wife and young son, and depressed at his father's refusal to help him, Claude attempted suicide by drowning himself in the Seine River. Fortunately for the world, he proved inept. This was a time of hardship for the young family as Monet's paintings sold only modestly. Louis-Joachim Gaudibert's reappearance in their lives became important at this juncture. He believed in Monet's art and became his patron, ordering more portraits and purchasing other paintings. This allowed Monet to paint and take care of his family. Monet painted Camille in *On the Bank of the Seine, Bennecourt*. This small painting became one of the greatest of Monet's

Claude attempted suicide by drowning himself in the Seine River.

oil sketches. It reveals early indications of impressionism, with vibrant blues, greens, and yellows reflecting light off the staccato brushstrokes. Perhaps the increased exposure from Gaudibert's patronage led to the inclusion of five works of Monet in the International Marine Exhibition in Le Havre, where Monet was awarded the silver medal.

Claude and Camille married in a civil ceremony in June 1870 at the town hall of the 8th Arrondissement in Paris. A friend of Claude's, the painter Gustave Courbet, was one of the witnesses. Camille's parents were present, but Monet's father and aunt refused to come, believing that Camille Doncieux was a poor choice. Claude-Adolphe Monet was financially stable but refused to help his son. The Doncieux family had only a modest income and insisted on a marriage contract that allowed Camille to maintain control of her own small dowry.

Claude and Camille married in a civil ceremony in June 1870

Soon after their wedding, the Franco-Prussian War began. Not wanting to

repeat Claude's military service and fearing for the family's safety, the Monets fled to London, England, where they stayed until the end of the war. It was in London that Monet met Paul Durand-Buel, who became his first art dealer when they returned to Paris. This trip away from France and familiar landscape proved to be a needed spark in Monet's artistic development. He was now painting new landscapes and images that would stay with him, influencing paintings later.

The couple and their infant son, Jean, traveled to Holland and spent the summer in 1872 in Zaandam after the end of the war. In the fall, they returned to France and settled in Argenteuil, an industrial town west of Paris. Monet's technique developed as personal and recognizably unique. Monet had befriended photographer Felix Nadar, and from Nadar's studio he captured the vibrant Paris streets in *Boulevard des Capucines*. The busy activity of the sidewalks and streets became

Monet had befriended photographer Felix Nadar

short, quick brushstrokes—almost jabs on the canvas. Art critic Louis Leroy branded them as "black tongue-lickings."

This criticism became a flag of victory, and the name "the Impressionists" was embraced.

Monet's life was once again filled with his friends Renoir, Pissarro, and Manet. With his longtime colleagues and other artists, Monet helped form the Société Anonyme des Artistes, Peintres, Sculpteurs, Graveurs. It was an alternative to the Salon in Paris, and they exhibited their works together without the censure of the Salon jury. The Société's exhibition in 1874, held in Nadar's photography studio, stirred up critics who unwittingly named an artistic revolution. Monet's work, *Impression, Sunrise* was a diffused Le Havre harbor enveloped in fog. Leroy derided the painting and the entire group's oeuvre as an impression, not reality. This criticism became a flag of victory, and the name "the Impressionists" was embraced. Monet's paintings became more contemporary and experimental. He exhibited with the Impressionists into the 1880s.

As Monet was reaching his stride artis-

tically, tragedy struck his personal life. Camille was pregnant with their second child and became very ill. Their son Michel was born in 1878. Camille's health deteriorated, and medical treatment could not save her. Alice Hoschedé, a family friend and host to the Monet family, arranged to have a Catholic wedding at Camille's bedside just days before she died. Claude and Camille had been married in a civil ceremony boycotted by his disapproving family. Though not a religious man, Monet had Camille's happiness at the forefront of his mind as the end of her life approached. The priest administered extreme unction and sanctioned their marriage in the same visit. Claude's muse and model, the mother of his children, died in 1878 at the age of thirty-two.

Claude, grieving deeply, painted a last portrait of Camille—*Camille on her Deathbed*—left her room, and closed the door. This painting stayed in his possession for most of his remaining life. Another period of depression began as Claude

Claude, grieving deeply, painted a last portrait of Camille— *Camille on her Deathbed*— left her room, and closed the door.

and his two young sons faced life without Camille.

Monet and Camille had met Ernest Hoschedé and his wife, Alice, in 1876. Monet painted at their lavish country home, Château de Rottembourg, in Montgeron. Hoschedé was a wealthy department store owner and a patron of the arts who had purchased a number of Monet's paintings. Hoschedé commissioned him to paint a series of panels in the Hoschedé home. This commission led to a close family friendship. In the last year of Camille's life, the Hoschedés invited Claude to move his family into their country home along with their own six children, Marthe, Blanche, Suzanne, Jacques, Germaine, and Jean-Pierre. Alice used funds from her dowry to pay Monet's debts, many incurred for medicine and treatments for Camille.

Following Camille's death, in 1880 Monet painted a dark group of paintings called the Ice Drift series.

Following Camille's death, in 1880 Monet painted a dark group of paintings called the Ice Drift series. The last painting in this series, *Ice Floes on the Seine,*

depicts the rugged shards of ice bathed in soft wintry light in much the same way that he would later paint lily pads floating on his pond in Giverny.

Claude now found himself in a house with eight young children. Hoschedé himself had financial woes and was forced into bankruptcy and sold all his art collection. Needing to support his large family, Ernest moved to Belgium to escape his debts and pursue a livelihood. Monet continued to live in the Hoschedé house, and Alice helped raise young Jean and Michel. In the fall of that year, Alice moved her brood, including Monet's sons, to Paris. Monet now had quiet and solitude stretched before him at a house in Vétheuil. Monet's paintings once again became rich in color and subject as time moved away from Camille's death. His art was selling with more frequency, relieving the financial stress. As Ernest was struggling financially, Claude invited the impoverished Hoschedé family to live with him. Monet grew close to Alice and found

himself falling in love with this woman who had cared for his dying wife and their children. Ernest was now working for the newspaper *Le Voltaire* in Paris and visited his family in Vétheuil with less frequency.

Claude and Alice became closer as her husband stayed longer in Paris. She and Ernest became estranged, but they never divorced and rarely saw each other. Monet now carried the responsibility of his sons as well as Alice and her six children. He began to travel extensively, painting in different locales, generating a wider swath of patrons to secure his income. His letters to friends and family chronicled his journey and created a picture of a man exploring the context of his art and his life. He was sometimes gone for months but wrote to Alice daily as she cared for the eight small children at home.

Monet ceased wandering and came home at last. His devotion to Alice deepened. He painted her in balmy countryside settings; she became the new icon in his landscapes, replacing Camille. Their

life was strung with tensions that both held it together and maintained a dark undercurrent. The fact that they were living together unmarried was an unacceptable situation for many people outside Claude's closest circle of friends. An 1880 article in the newspaper, *Le Gaulois* mocked their situation and referred to Alice as Monet's "charming wife" while her husband lived in Claude's Paris studio.

Alice had what could be characterized as an obsession with erasing Camille from Claude's life. While he traveled, she destroyed Camille's papers, photographs of her, and objects of sentiment. This aside, Claude and Alice created a stable home for their brood. Durand-Ruel began buying and selling Monet's paintings effectively, creating more financial stability than Claude had ever experienced. In 1883, Claude and Alice moved the family west along the Seine to a house in Giverny. Claude found the meadows and light in Giverny irresistible. His paintings were not only *en plein air,* but *de la campagne.*

Claude found the meadows and light in Giverny irresistible.

"I am following Nature without being able to grasp her...I perhaps owe having become a painter to flowers."

Monet explored the Giverny countryside, soaking up the air and the light.

In 1891, Ernest Hoschedé died in Paris. The following year, Claude and Alice married and settled into a life together at Giverny. Their children were growing up together; Jean and Michel barely knew any other version of their family. Monet explored the Giverny countryside, soaking up the air and the light.

During this peaceful time in Monet's life, his fame and success were growing. In 1893 he bought some marshy land across the road from his house and herb garden. It was fed by a tributary of the Epte River. Claude, long ago fascinated with Japanese art and architecture, began planning a pond and Japanese bridge on his Giverny property. He petitioned the city and oversaw workmen as they drained his marsh, diverted water to the pond, and constructed the wooden bridge. He

brought in exotic plants and nurtured natives. Monet planted the pond with water lilies, rushes, irises, willows, and bamboo. This garden would become the principal subject for the rest of his life. Monet painted variations of this constructed scene 250 times; he painted it in different light, from different angles, and different seasons. Light was as much a medium for Monet as paint. The viewer must look past the lilies in his work to the reflection of the reeds and trees around the edge of the pool. Even with the density of the lily pads, the Japanese bridge casts its shadow.

Claude and Alice spent twenty years together at Giverny until his beloved Alice's death in 1911. The next few years were marked with tragedy. In 1912, Monet began to develop cataracts in one eye that clouded the colors he saw. In 1914, his older son, Jean-Armand, died. Jean had married Alice's daughter Blanche, who was a great favorite of Claude's. His younger son, Michel, left to fight in World War I, the Great War, as the Germans

Light was as much a medium for Monet as paint.

marched toward Paris. The French army successfully defended Paris, but a great deal of northeastern France was brutally occupied by the Germans. Monet's old friend, Georges Clémenceau, nicknamed *le tigre* for his ferocity and tenacity, headed a coalition government determined to defeat Germany. He negotiated the Treaty of Versailles in 1919. Monet was devastated by the wartime conflict and the great deal of loss in his life. His greatest comfort became his devoted daughter-in-law, Blanche, who cared for him as they mourned together.

Monet was out of step with the avante-garde in the art world. Impressionism was being radicalized by Vincent van Gogh, Paul Cézanne, Henrí Matisse, Paul Gauguin, and Marcel Duchamp. Younger artists, inspired and emboldened by the radical Impressionists, were marking their own place as Cubists. Pablo Picasso and Georges Braque were at the forefront of the explosion of controversy. If the paintings of the Impressionists were

Monet was out of step with the avante-garde in the art world.

the mere idea of an image, the Cubists' were unrecognizable. Monet's reputation and talent were still held in highest regard by those not ready for the energy of Cubism. He was awarded a commission by the Orangerie des Tuileries in Paris for what became a final series of twelve water lily paintings. The museum had halls with huge open walls. Monet made these paintings on large scale, saying that he wanted the paintings to evoke a haven of peaceful meditation. The project consumed and exhausted him, yet in letters he expressed the need to "render what I feel."

"Everyone discusses my art and pretends to understand, as if it were necessary to understand, when it is simply necessary to love."

By this time he had cataracts in both eyes and was nearly blind. In 1923 he finally consented to let Blanche take him to have surgery on his eyes. It was a success,

Monet made these paintings on large scale, saying that he wanted the paintings to evoke a haven of peaceful meditation.

and after recovering, Monet found that he had not been perceiving colors correctly for years. He went back to his later paintings and meticulously touched them up with richer hues.

"Color is my day-long obsession,
joy, and torment."

On December 5, 1926, Oscar-Claude Monet died. The art world and all of France mourned his death. Blanche respected Monet's wishes for a simple funeral with only about fifty close friends and family attending. Tradition called for a black cloth to shroud the casket, but Georges Clémenceau draped a floral patterned cloth, more appropriate for his friend, this man of light and color. Monet was buried in the church cemetery in Giverny.

Michel Monet was the only heir and inherited the house and gardens at Giverny. He chose to donate them to the French Academy of Fine Arts in 1966. The Claude Monet Foundation was put in

place to honor the artist's work, and the house and gardens were opened to visitors in 1980.

After the death of Claude Monet, his influence on the art world softened. Impressionism had opened a floodgate of brilliant exploration that hit some of the same nerves that Monet's staccato brush-strokes had years before. The Impressionists had won over their critics, and now the perception of artistry was being stirred up again. In the 1950s, a renewed interest in Monet's work took place. His large scale and innovations inspired the Abstract Expressionists. Monet was a master colorist. He applied paint in small strokes, building up the surface, encapsulating light from within. He elicited the balance and contrasts of color. This represented a breakthrough in abstraction and influenced the use of surface effects in modern painting. The way Monet diffused objects in his paintings led directly to abstraction taken further by Jackson Pollack, Mark Rothko, and Willem de Kooning.

Monet was a master colorist.

Oscar-Claude Monet, *plein air* painter, cartoonist, portraitist, colorist, Impressionist, left the world a thrown-open window into his mind's eye, one that is vibrant, evocative, rich, and eternal.